Songs of S. | Robert Seydel

S. occupied an apartment in a house in Amherst, Massachusetts, on a gray street around the corner from Emily Dickinson's manse on Main Street. Not that much is known about him as a person — there are some hospital records to consult and various official documents (tax records, census reports), and a few saved letters from presently unidentifiable people. But he wrote prolifically — these small songs — and kept a journal, and made collages and drew as well, for example the small colored pencil drawings, of heads for the most part that look like hillocks nestled among the valleys of what might be Amherst's nearby Holyoke Range. This line of hills was visible from the window of the room he used as his studio. The eyes of the figures in the drawings and also in his collages are generally colored red.

These pictures betray, as do his songs, a certain lack of proficiency, while simultaneously developing a stance of innocence and reverie far from the precincts of the technical. His poems, journals and pictures were found, along with a great library of books, in his apartment, which he abandoned quite suddenly. There are hundreds of these little songs, as he sometimes titled them (more often he supplied no title at all, nor is it possible to discern any order for them, chronological or otherwise). This book represents a first selection of some of them.

The riddle of his hat, I fear, is a question above antiquarism, not to be resolved by man, and he himself as shadowy as Henry Pimpernel, and Peter Turph, and old John Naps of Greece.

John Livingston Lowes, *The Road to Xanadu*

what drums on a hat

levels a forest

my head is a light

(with nerves)

it jumps

like a toad

into the lake

then sneezes

for all it's worth

WHAT THE FLOOD LEFT

Dear ripen
all, the Flood
a Queensbury
by half to say

& if Melba's got
mold hurray
I draw peaches
on the floor

Dine on quinces
It's a raw
foot, magnetic
in Texas

It runs thru
Cherokee & has
long needles
studded abt it

Dreamt rain

 The name's handle;
An angel in the air
Not my mustache
 growing, illusory

but where cows walk
& milk maids
 beautiful at dawn

the mountains bend down
 they bend down the distance

 Tea cups rattle
at their coming

 & you too
 like a bee, run

into my mouth

everything
 humming now

 & prick me, I'm so human

I was stretched out like a regular guy
beneath the sky. Nothing moved.
The sun went up & looked at me.
Hello Sun. But nothing replied.

Then I saw the ants crawling abt;
they & the sun the only things.
There were no vehicles
& no people. No one is a business

Person or a hotel maid or postman.
Sometimes I think, this is it.
But there's always something more
Waiting somewhere. Like in the plants.

TIERRA DEL FUEGO

The tongue
 you think
is done

 white
on the river
 side, purple on
the Plain

 Kosher Jewish
butchers sang
 stranded in
Tierra del Fuego

Sonorities
suffer
 my tune
 or tuneless
ness.

What is air
 but day
 or white.

In the green
 peck
a spot
 of red.
 Dead.

 The light
is as lotion
 on my body, a
 grease of
the immoral sky.

Music or
 its air
goes out,
 not sonorous,
 not white.

Even as I sing
 I suffer dis/
tractions,
 of needles

& suchlike
 sharpened things.

I want to, up
God. I want rather
to up God.
God is up or uppity.
You & I are up.
Up is you. I is pue.
Pue up God rather.
Rather pue God up.
I want, rather
 a ladder.

Here say song is hat,
 a covering from the rain
that's sad Each
 is another, sounding me
The rube that walks
 his little mutt & soup
that's slurped, embarrassingly
 Remember that buxom
waitress in that damp place
 by the sea? She's two
kids & no car a dingy rental
 on a hill Even hers
is hat I'd wear
 against a soaking rain

Gray
& the sky
fungible
if you open
it

Burrs
descend from
it like birds
pigeons
particularly

& airplanes
go in & out
of it
every day
day
after
day

& when I've
finished
so they say
not even
the burrs will
remain

It's a sky
remarkable

in particular
for its
consistency
which is like
pudding
& for which
I love it

loving pudding

The burrs
in the sky
are like little
pasty
globules
of sugary
stuff
in a pudding
somewhat
like tapioca

is a turd

 in a dream

a sign for hat?

 if my mother thought so:

 ice cream! if not,

 lie. (the suit is in

 the fridge she sd)

 (in another dream)

not mine.

The space of the city
isn't simple. The rose
flower of the street
carries me.

Gray boat in the gray
light, rushing along.
The flower & the gray
sea carry me.

City of flowers, sea
city, seal my head
with signs. When I rose
to go, there was nowhere

Was not in the light.

SONG

Today I want to buy a cow
Today & not tomorrow
Today I want to buy, not a sow
nor with a sou
Today I want I only want
To buy myself a pretty cow
To tie up in my garden
& let it eat up all the little flowers
Today & not tomorrow
Today I want to buy a cow

I would move on an antipode
 of me to see
green come out of
the arc's turning

there at an edge that is an edge
 to see

Nothing is real that turns in me
Nothing of the real

turns in me
Turn in me

 there at an edge
 that is an edge to see

POME IN FOUR PARTS

i.

A box harbors
my mouth, the tide
goes out with birds
sitting on it, & clouds
that look like teeth

ii.

my thoughts go by
like strange fruits &
small animals,
to such degree that I realize
they're not mine

iii.

mind supplanted
by strawberries in summer
in fall fails to find itself
in something else

iv.

The sky pattered of fruit
Birds in it wheeled thru it
I saw a lemon cloud
I saw it near 1st St in the sky!

I'm wearing a trellis
over my head. The walk
is wet & shiny. Somewhere
there are sea lions grunting
on an island. Somewhere
there's Mabel, contrary
but beautiful.
In the wind is the sea.
In the sea somewhere is
California, sometime or
another. It's floating
west to east,
a hummingbird under
my shoe.

SONG FOR LICHTENBERG

Does this go green?
 it is happiness
O Lichtenberg
 your flowergirl

& what is nature?
 (to his students)
it is happiness
 dear flowergirl

Even a hunchback
 has a home
green & flowering,
 & a bed!

The happy man
 & his flowergirl
sing & sing
 to the happy dead

PATHETIC SONG

Big rock

 show me the way

Big fish

 you too

The sky's so big

 it make me wanna cry

Little hare

 you wanna do that too

Big rock

 show me way out

& you too

 big fish

Big rock

 little hare

what we got to do

 but cry & cry

all the way

 to the moon

My art is
a covering
hat. Pistils fill
it, of flowers.

It waggles
like a duck
on my head.
Feet blind me.

& song.

It's dawn which sounds
& my eyes roll & twitches
follow down both of my arms.
Is it illness god speaks in us,
so that the one saying limits
locates his perch? It is
illness I hear, swallowing
my pill. Now when dawn
comes in at the window perches
go, & the ailanthus in its pot.
It is useless, dreaming, & likewise
to rise. Dawn is useless
& an illness. Give us our pills.

This great bent book

 of words

 falling on ears

& eyes —

 words

 like water &

like water on rocks

 & like rocks

 on the tongue

& in the ear —

 bend

 the self

& bend it thru time

 so it is

 no more

than shaking

leaf

 or chord

 vibrating

so it is

 no more

than man

in time,

running

 like light

 on water

FISH POEM

I reveal me
in it, white

as mackerel,
quick as the albatross
above it

When it sings
(the Poem)
I will be Fish!

Obi Roland of Publicity
With Miss Keene the 28th
& Aristotle set out together
for Milk, reborn, &
Buchenwald. The victims are
detriment, cold, sd Roland,
looking into his Mariachi
star. A scorching inspiration
replied Miss Keene. 3, sd
Aristotle from his
plinth. The finger pointed them
northwest toward the fringe
of Red Lake. No em place
in a ca, in a ca, their final
words on the matter.

Matter
& natter

of tongue

Bent, ill
 or tight
as night

in a pocket
like a locket

where the horse says, run

SONG

To bend across a drum
The name: a bird
To bend by stick
The flute: a song

Not a bird or name
Of bird to bend
In a drum a flute
In the flute a word

To bend in a drum
A name: the bird

Flute &
Drum
& Bird
A word

To drum a flute
To bend a bird

To bray

 in the light;

that is what it's like to smoke

 near town

 on paving bricks

 hot in the sun.

 Pshaw!

 the green belts

of the paths

 trip up

 the apple carts.

Bray honk (goose

 my foot.

 The town went up

 to heaven

& left

a small light

here.

I thought, this broom
is my tongue, & licked
at the wicker. Wasps
leapt up & caught
in my knickers. Green,
I'm a woman I sd
& settled down to a book.
How I travel there with honey
in my navel & the best
manners in the country.

JUNE POME

Late night hospital hum
I am torn up — a swamp in the heat
The trees wicker in,
dangling must There's a
bug on the ceiling
clicking abt & one toenail
hurts like hell
But then my whole body's
falling apart At least
the flowers are coming up

FINCH

Finch like Faust —
a deal with yr
maker? Big beak,
small beak, middling
beak, minor, the
seed's in the sauce,
you're sunning on
the islands

ANVIL

The anvil
 is an image, lodged
there like a toothpick

I set it in place near a huntsman's
 lodge, in a poetic
forest, that is also real

Now every day the anvil
 sits there, quiet
among the poetic trees.

Words gather
 around it, &
sharpened blades

The huntsman is also,
 in his lodge,
an image

in that forest that is like an ocean.

SONG

The wind a-round
 a pin;
the blue color
of my skin.

Sky is an illness
 in my eye. My hand
 raised in the wind
is like the land
 razed by the wind.

The sky &
the wind.

The land
 in the pin. My eye
on my skin.
 Blue as the wind.

BUCKETS SONG

I barely shit
when I sit

 to shit
I barely piss

when I do

but the rain coming

up the coast
is not like that

it will leak buckets
 thru my roof

The sky means another thing
Is that my hat in it?
My nose points up at it.
Where I look up: sky (is hat).

Also, my nose looks up with me.
Then say there's an eye in the nose?
Perhaps there's a sky in the hat.
But (outside) sky is certain in the eye.

You can see it reflected in it.
But there's also an eye in the sky:
that's the sun!
& it watches me too, with its nose.

Calipers of the stars.
Toss yr hat in the ring.
It is a head flying
above mountains
when you have courage
& the night is large.

Should a poem rise in it
the heat would not matter
it goes out thru my hair
& tangles there.

If the poem made a griffin
would it fly off also? The small
recompense of things made sigh
& the one that waves them out

is an Admiral.
He wrote me, The tear is
an Intellectual thing
 & a griffin is also.

If a poem is a prayer
let it rise out of my hair.

ELECTION DAY POME

November drum — the
gray sky. Which of
East, now lumbar
twitch: the white
patterns it all.
So that flue
open, the catch of
throat, is fall. On
Election Day
hope I bask, in the soup — my
countree tis, almost
of thee.

SONG OF THE RAW AND THE COOKED

Now what I see is raw.
White fume of the cooked.
Now what I see is cooked.
Time runs out on the shore.

Sea is strand of me?
Now what I see is running.
White like the Pleiades.
White & green as the sea.

The raw & the cooked
this is.
Raw is red, & red.
White is

 the fume
of the sea.
Now that I see what I see.

A cant of time
Loose wheel
in the mtn haze
A crow there
glossy black
My name in the wind
& on its beak
whoo whoo the rocks
slush the big trees
pierce the sky
Chalky me not
one but many
not two but last
in pattern
symmetry & hope
The mtn points
a fist at me
gnarly fist
rocky me
History's maze
not revelation
I sit in it
outside of it
dreaming time is
a carbuncle

Where a tongue pokes out
a penny is.
Green is tough on copper (age).
The margin of a table:
 place.

 A hat, yes;
 a pome on
 a chair.

Where an animal sits
furnishings go.
But the wind carries
a gob of spit

it strikes the hat
&
topples it.

Not drum —
 my eye
 is in the hat

Here goes green
 running
 along the field

Follow. Follow.
 My eye
 follows green!

A drum's
 a hat
 in the field

OCTOBER SEASON

Red
Sox vs
Angels

(Halos)

(Halos)

& Metro
Politans

Gone
Gone

October
Sea

Son

Not

So
Nice

MARY BUTTS

The mysterious Mary Butts —
 her grandfather knew
William Blake & received from him
 a perfect poem.

Did Thomas Butts show Mary
 Butts the poem written
in the poet's hand? Fire to
 Fire, then, we can guess

Mary saw lightning
 cut through an Oak Tree.
The result in her
 was another song; mystery.

Lilt: a
 thought
 bent —

the white water
 of day.

 In the ear
 wax, in
 the eyes

crust. A
 mtn
 in the mind

to climb.
 A river
 on it

to come down
on. Boats
 in the shade

dreaming of it.

SONG

I'd prefer his rare
 eyes swung
 green to the copse
 a long way out

where wilderbeast &
 cat lit,
 wise for the trees
 & seeking a stint

with the parallel bass
 counting
 one & two, all
 the distance to Greece

Here the green goes
galley, ocean-wise,
& toes & genitals move
under the covers.
Ledgermain is it, how
we cross the seas —
eyes on dots that bounce
on the waves?
 Clouds
glimmer, my caboose is
too big, girls gather
on the green island shores.
Its food is there, turtles
& mead. Dream is river
& a world to see. Give me
numbers, my gizzard-increase.
The seas lisp along
& the riven, my greed.

ON WINDOWS

In time windows fail us.
The window — not a happy town in me.

I sit sometimes

 in the thick,

 spinning

out no thought

I twist in my seat,

 to no avail

My eye is broken

 at its tip —

 do whales ride

 out

from it,

the big sweet

animals I love

so much?

 I wish I had

a fish

stick

 or a penny

 for every ninny

sitting

 on a tram

 or man

 there

 in his depression

 riding

 his own tail

Even what I fail to say when I say me,
later in the day, my eye pink, I say regardless,
thru what I don't say or can't. Or is it, when I do,
that I don't or vice-versa, & is that Moral?

If I have no compass to steer by
where is & what is, the Moral? Or can only
the larger stars & the heaven we thought once
make a human morality?

I don't say what I say, I don't say what,
& that is not moral. I say what I don't say, & that
likewise is not moral.

Bio-graphy is small without a code.
I don't live, altogether, therefore have no or little code.
Nor do I graph bio, because living little.

It is all very ugly, that way.

The pome

(sleep)

a noodle in

the word

A worm

in the bed.

The brook —

 no wind

 Across the brook

no wind

 Time

 is not

 in the rain

Time is not

 in the rain

 in the trees

 Time is

not in the birds

 in the trees

Rain

 but no wind

Trees

but no birds

A brook

that is filling

with rain

is not time

SONG

I want to know
 the mind in me
 that is so hid
I cannot see

what it is
 that makes me
 (wily-nily?)
what I am.

Not a scare crow
 nor a snow man
 nor the man in the moon
is made by a hand

attached to me —
 poem & picture
 don't reveal
what I am.

The mind in me
 is hid in them.
 I cannot tell
what it is

that makes me
 in making these
 or (wily-nily?)
what I am.

if the moon is also
 in my mouth…
both shoe &
 white slick
of a slug…

if it is here,
 a leaping hare
in the reeds…
 or there, quick
like fish
 in the stream…

it is it is
 mercurial,
moon,
 a shoe in me…
my mouth
 in the moon…

A needle got stuck
In my eye
Before I could pry
The needle out
The world shook

I live in a sty
That the world is beautiful
Is a lie

DARWIN ANECDOTE

I like to think
Darwin sat where
amber beads
propelled his thought

Birches that bounced
past his window
had crows in them
who saw his piano

& waved as he danced
on the wet floor
Darwin Darwin
they said as they went

this,
is not
beautiful

my
eye
chokes
up

blocks
there
building
bees

& the
squirrel
at
its nut

It's a long
music the children
are

days go out
beyond them
days their eyes

are saucers

they love the days
the tide the wading
birds & their feet

the sea goes out
beyond them
the sea their eyes

are islands

the wonder of the day
is in them

SISTER NUTMEG

How many hats are in the barrel?
Sister Nutmeg knows —
There's cruellers in the pantry box
& doves' feet on the linen

Sister Nutmeg
Open a can of peaches for us
Where's the butter? Get us cream
How many hats are in the barrel?

Where Sister Nutmeg goes
There goes also what she knows
Sweet milk & smells the Little ones cry
 Go up your nose

The wind is a motor
 in my mouth. Every
cliché is right. The sky
 pulls on my eyes,
plants lines of nerves
 in them & pulls.
Nothing personal in
 the personal ads, even in
The Voice. Check:
 Every waiter is
a dim motor. Every
cliché is right. If water
 has its own time,
so will I, in the sky.

HATSKY

Sky
Sky&Sky

Sky Blue
Hatsky
Hatsky
Sky Blue

BlueSky
HatSky

Hatsky
HatSky

BlueGreen
DrumGreen
BlueGreen
DrumGreen

BlueSky
Hatsky
SkySky

Skysky

SkyBlue
Hatsky
BlueDrum
BlueSky

SkySky

Sky
Sky

HatSky
Hatsky

Here, if
I dream of
a bird

 the bird says,

"Here."

Looking for the word
"oxidize" or
"cream," he took
his shoe

he stood in the rain
every slamming
door sd "vain"
every other cough too

WINTER SONG

The poet is strange

 in his feet
 a crank gone out
 on a frozen brook

Earth, he cries

 is not me
 trees are not
 nor flowers' seeds

My feet are drums

 & drum on you
 my feet, this verse
 will fall thru ice

I do not sing

 to you, Earth
 I will not make
 the Spring

FOR JOE BRAINARD

The Madonna
is my momma
Good & Fruity (Joe Brainard)
I make Prell
 altars
to her beauty.

At my core, dream

(ing) pantaloons

as the fabric cambric

& fab u loss of me

like the switch (hit it!)

jazzmen toot

in my core, dream

(ing) a 19th cent

ury

SONG

Is it better to fall
by ruse or the real?
I fall by both, in love
with the deal

earth has made with me

Nothing to dream is the nothing
that is white & long
as a paving wheel

I go out of my head
& in & out
dreaming the earth

still loves the dead

How you pitch a
bird from the peak
of your roof does matter

it goes therefrom
to where

a cloud is bright
in a sky
full of duff

you could not
place a brighter penny
on your eye

SAN POME

An image drawn
 & a pome
in it

the San
 (clicks tongue)
& draws

the Rain Bull out

like
 no animal
else in

the water hole

Here run up the margin
of the sun bright
 dowagers
against the rain & tides

& my nose is full of yellow color

Parquet, conundrum, sleeve of
the green filagree,
it's a shoo-in to say, yr hair's
 on fire

Mary, Mary

It's someone else
not me, who says
I sing

to the day, to mulberries
dying on the tree, to the white stroke
of noon

in my head

 so that
I fall, stroked &
foaming, my time come

round

it is like this
dead, another
voice in your head

A dioxide wind
runs thru me & if I groan
the air is pendant regardless
& the waste water drops
in my lungs with bells going off in it
Even the thunder is signal I fail
eating peaches but who will create
the loon in the air the tusk
of the pig I want to pitch my tent
in the heart of being write
the dioxide poem in scales
of old animal it is here when rain
falls that I know what I am

& the sun declines exactly
like the moon
& my mind is a pearl
like the moon in a sky
full of grit & bits of sand
& my sore arm (bad
heart) points a way across
the river, that flashes like
a whisk broom on the floors
of the night, & one moment
before I wake will be like
any other while I slept.

CONFESSION

I am a hovel

 & a black bag, precarious

white, near

here

Nothing pleases like the rareness
 of the day.

All life's mercurious
 experimental, not

to be gainsaid.

 I am rare
 therefore
 in the rope

King of Feathers

 tangle in (fish) line
like a whale.

What goes Pop
in the head?
Blood vessels art
Pop? Andy's home
in comic books.
Vessala too. &
Vaseline? In the
head, Pop — a rhino.
Bugaboos. Grease
lightning, say.
It's all in the nose the
Rose sd. Quick as
a peach today.

In the molt, a
last bright dream
in it.

Not that rigor marks
catastrophe
in it.

Days have smell
of swamp
in it. Days,

last best hope
in it.

SONG

A dog with a flat hat
Shares a dog & a door
With a flat man & a fat
Door where the ushers stand

A flat hat & a square dog
With a set of tics
Remains a dog to a door
Of a fat man's flat

Therefore the door is a dog
Of a fat man whose flat
Shares its fat with the tics
Of the nervous ushers there

Or an usher is flat & fat
Wearing a hat
Or is otherwise a man with a dog
Who is square & fat

& shares his door
With the ushers there

ON FEATHERS

& I do not want to think
abt feathers

(or fathers)

I batten on elsewhere like a futuristic
beetle. Recycled wind, helioport
smoke, I am in a movie!, it is
honey & gloss in my expanding head

When the screen comes close & shuts,
when the seatbacks roll & space
darkens, then I'm truly beetle!
battened in my hard, black shell, glossy

as the night. The mystery is in my
coming to this, what we all are
in the distance that zooms meteor-like
past our ears & into our heads

 Great rebours
twist in space like trains gone fugitive
We sail on roads that no one laid out

GHOST SONG

he sd when he says
ghosts when he says
he says goats

he says when he says
goats when he says
he says ghosts

he says & he meant
& the goats
he says in the wind

he says & he meant
& the ghosts
he says in the wind

& in the wind
& on the plain
& in the wind
across the plain

he says & he meant
goats on the plain
he sd & the wind

he says & he meant
ghosts he sd
playin' in the wind

& in the wind
& on the plain
& in the wind
across the plain

he sd when he says
ghosts when he says
he says goats

I think the sun
is right, by ellipsis.
The stem is caught in
the grinder.
The tree matches my leg in shape.
Twenty of them in a
matchbook give me light
to cry by. What is
out there is almost in me.
Like, the squeeze is on
they say.

THE BRAZEN CAT

The brazen cat
is a quick monster
it steals my socks &
shits beneath the bed

My brazen cat's
brown & white
& likes pinching girls
& many fireflies

The moon's round
where my cat sits
the sun is
not its friend

Many fireflies
congregate on the porch
the cat licks
them into light

A two-legged white trop
weird thing — moves me
& moves him & everything
is cinematic — like at the
movies in the dark &
someone gets up to sing
along — cripp — it's Madonna
& all the boys go Wow,
wow — it's Peyton Place now
& my mother's there — & then
the weird thing comes on stage

SONG

In Brockton Mass
all the birds go bing
even the pretty black
girls sing
as they flounce past

& the cool street does
a double-take & flips
over, becoming Queens
which is the town my
aunt lived in

"I need air to breathe"
(Picabia)
& the white sky

Mice take to cakes
like I don't know
what

Beaver Pantry
Tiddly winks
Here's to Muscatel

& you

Shut-eye
in
the lobby

I shld never have winnowed
my noodles down now the
white boats move on the mauve,
green sea, slowly, slowly, by canvas

Everything is electric but me
Syncopation, say, is important &
also a revelation of characteristic
humors; whereas, & likewise,

moats hold no fish here
Spent, my force is charade
Like "limp" &
not lamp, there's grease

on the parquet floor &
commandeering flageolets
So that I tease out day, wigwams,
the color of a coat

But then there is "Whippets" like a dog
running thru another field

It's hard to get the voicing
right; the word turns & becomes
a mushroom
 Every time
as the sky clouds over the nostrils
flare. It's a boat that sets out,
a spot of grease where the car
sat. Green is of the matter also,
green or red or a spot of yellow
(here beneath the trees)
 together
we sat & laughed. It is hard to get
the voicing right. Birds set out,
& then a wind -

NOT SONG

Not very many, not once

Not even in the air

Nor too many, not again

Not even to break bread

Not enough, even now

Not even to ship out

Nor too many, not again

Not even to be men

Green Arrow
Causeway
Run White
Ninnie Loli
Pop Seep
Bog Sheep
Path Sun
Yellow Mark
Delivery Man
Come

SONG

I jump
over & over
the sun
like a cow

(proverbial)

while watch chains
glimmer & the
diet girls wind
down

"Nothing is noon
so soon
as a loon
dancing
upon the moon"

(they sang)

while I dug
spangled space
& caught a cold
in my ear

(no sow's purse)

yeah

Is it that it's green
or from the wind? In my hat
perhaps it's fog? Or the rabbit
that died in the grapes?
Not that a poem is good for
such, talking & all
in the Fall.

 It's silver
vine stalks, as in the weight
of sun. Or the crop
of peas in the cavern
in the forest.

 I'll hold
out for a hat made of mink,
& a wind no less cruel for
breathing. Here in the high
house by the sea I see:
whale smoke, wind, the green
scalloped sea.

Robert Seydel was a deep reader, and poetry was central to his
intellectual and artistic imagination. Over his life, Robert produced
hundreds of visual works using many alter egos in ongoing and inter-
related series that move freely between lyric and narrative modes. I've
often felt that one can read Robert's visual collages like poetry, that
is to say, their private annunciation, gnomic pressure, and animated
imagery are all techniques shared with the composition of poetry.
He worked prolifically in notebooks, sometimes calling them "knot-
books." This notebook writing was a highly evolved daily practice
for most of Robert's adult life and was clearly his "laboratory" — it
took the form of doodles, collages, a commonplace book of citations
from his reading practice, lyrical runs, personal journaling about his
life and, of course, his thinking about his art and art in general. That
is to say, he worked not on paper but on pages, so there isn't a division
of his overall practice: poems and drawings, critical comments on
books he read along with diaristic entries, together constitute the total
work. Many of his visual tools are a writer's: whiteout, pencil and pen,
erasers, tape, type, and newsprint. Robert's work, viewed collectively,
has a voice as much as a vision whether its tone is elegiac, monumen-
tal, private, or whimsical.

Robert thought poetry to be the highest art. We would often argue
about what might be the greater practice, visual art or poetry, each
arguing for the other's primary discipline, and then at some point
we'd shake our heads and laugh, neither thoroughly satisfied with the
answers we had put forward. From around 2005/6, Robert began to
show me poems and free-writes in his notebooks, which contained
both discrete lyrics and journal writings from his major alter ego, Ruth
Greisman; his writing was uncanny and true. I encouraged Robert
to type up the poems and to pursue his desire to create visual texts of
"Ruth's journals." Thankfully, these visual writings of Ruth can now

be found in the revelatory *A Picture Is Always a Book: Further Writings from Book of Ruth.*

Then, in the summer of 2008, I remember talking to Robert about his desire to publish a book of poetry, offering some strategies of how to go about it, and by 2009 he had begun to assemble what would become *Songs of S.* The first draft had some interludes of prose narratives about his fictional character S., the "author" of the poems. I suggested that if his sole interest was in having a book of poetry, then he should perhaps concentrate on the lyrics, at least for this book, instead of creating an evolved architectural narrative. My thinking, our thinking, was that this book would be the first of S.'s writing and that if he indeed wanted a "book of poetry" he should start with the songs. I culled the songs I favored, he added more, and then we made line edits; nothing out of the ordinary when friends show each other work. We often spent late nights with a book and read aloud to one another, laughing and talking; I can hear the deep effect of our ongoing and interrelated conversations on poetry and practice in this work (and in *Maybe S.*), as well as correspondences with some of the poets we were reading closely around this time — Wallace Stevens, Emily Dickinson, Robert Creeley, and Robert Lax, to name a few.

This book was composed and assembled between 2008 and 2010. Robert left two fair copies of *Songs of S.* from which we could put together this collection, both of them similar but in one there were additional poems and the apocryphal headnote at the start of this volume. This present text is a combination of the two and incorporates line edits from both manuscripts. All odd spellings and misspellings are intentional. The final order is also, for the most part, established from the two texts.

To my eye, Robert is a poet, by which I mean to say that he has established an idiom and vocabulary and a syntax among his images. He has a poet's sense of form, a tightly coiled energy of Possibility (in the Dickinsonian sense), a love of metamorphic intensity and of mysteries on the verge of being revealed. In *Songs of S.* and, to a greater degree,

in the accompanying book, *Maybe S.*, we find a window into Robert's practice of visioning an alter ego; sadly though, this work is inseparable with his own suffering and failing health in the last two years of his life. Robert used to use the term "death-work." For example, when we visited a major retrospective of Joseph Cornell's work in the summer of 2007 in Salem, he described a room filled with Cornell's stark white hotels as such, or again when he showed me Robert Frank's book of destroyed buildings from the Lebanese civil war, *Come Again*. Perhaps we might consider the figure of S. as Robert's own death-work, making *Songs of S.* his most elegiac work, as he writes: "it is like this / dead, another / voice in your head." Such is the fate of life and art.

— Peter Gizzi
Holyoke, June 2014

ABOUT THE AUTHOR

ROBERT SEYDEL (1960-2011), a professor at Hampshire College in Amherst, Massachusetts, was an artist and writer who left behind a layered and original body of work. Seydel's ongoing and interrelated series incorporated collage, drawing, photography, narrative and lyric writing, often using various personas and fictional constructs, such as Ruth Greisman whose works are collected in *Book of Ruth* (Siglio, 2011) and *A Picture Is Always a Book* (Siglio, 2014). *Songs of S.* provides a new opening via another of Seydel's alter egos into a vast body of work that is marked by an unrelenting sense of play and embedded with an eclectic body of knowledge.

ACKNOWLEDGMENTS

The publishers would like to thank the Estate of Robert Seydel.

The text of *Songs of S.* was edited by Peter Gizzi.

Maybe S. was edited by Richard Kraft.

The editors would like to thank Anna Gaissert, Lisa Pearson, Jonathan Ruseki, Emmalea Russo, and Matvei Yankelevich.

The publication of this book was made possible in part by the New York State Council on the Arts with the support of Governor Cuomo and the New York State Legislature.

State of the Arts

NYSCA

COLOPHON

Songs of S. by Robert Seydel © the Estate of Robert Seydel, 2014
Note on the Text © Peter Gizzi, 2014

The edition is limited to 1,500 copies and includes the booklet *Maybe S.*

Designed by Don't Look Now! in collaboration with Lisa Pearson and
Richard Kraft; typeset in Fournier and Caecilia by Emmalea Russo.

The book was printed and bound in the United States by McNaughton
& Gunn using recycled paper, with cover stock from French Paper Co.

First Edition, First Printing, 2014
Siglio Press & Ugly Duckling Presse

ISBN 978-1-938221-05-7
Available to the trade through Artbook/D.A.P.
155 Sixth Avenue, 2nd Floor, New York, NY 10013
Tel. 212-627-1999 www.artbook.com

Siglio Press Ugly Duckling Presse
2432 Medlow Avenue 232 Third Street #E-303
Los Angeles, CA 90041 Brooklyn, NY 11215
sigliopress.com uglyducklingpresse.org